Charterhouse

ABOUT THE AUTHOR

Stephen Porter, until his recent retirement, worked for over 17 years for the Survey of London, a century-old project devoted to the history of London's built environment. He is head archivist for the London Charterhouse and a Fellow of the Society of Antiquaries and of the Royal Historical Society. He is the author of the official history of the London Charterhouse, also published by Amberley Publishing. He has also lectured on the Civil War and the Great Fire of London at the Museum of London and held research posts at the University of Oxford. After 25 years living in the capital he now lives in Stratford-upon-Avon.

'A model history' GILLIAN TINDALL, author of *The House by the Thames*

Charterhouse
THE OFFICIAL GUIDE

STEPHEN PORTER

AMBERLEY

First published 2010

Amberley Publishing
Cirencester Road, Chalford,
Stroud, Gloucestershire, GL6 8PE

www.amberley-books.com
Copyright © Sutton's Hospital, 2010

The right of Sutton's Hospital to be identified
as the Author of this work has been asserted in
accordance with the Copyrights, Designs and
Patents Act 1988.

ISBN 978 1 84868 376 1

British Library Cataloguing in Publication Data.
A catalogue record for this book is available
from the British Library.

Typeset in 9pt on 15pt Anselm.
Book production by Amberley Publishing.
Printed in the UK.

MASTER'S PREFACE

A new official guide to Charterhouse in London heralds the quatercentenary of Thomas Sutton's remarkable foundation in 1611, which still flourishes as an almshouse in London and a school which moved to Godalming in Surrey in 1872.

This beautifully illustrated volume provides not only a guide to the historic buildings but also a comprehensive account of the four distinct chapters in the history of the site (burial ground, Carthusian priory, Tudor mansion, almshouse and school). In addition, there is an account of the artwork of the house and a glimpse of the day-to-day life of Sutton's Hospital in Charterhouse.

We express our appreciation and thanks to Stephen Porter, Honorary Archivist, who has a vast knowledge and understanding of the site and its history, for compiling this work. We also acknowledge the contributions of two Brothers of Charterhouse: Stanley Underhill for the description of the artwork and Brian Newble for his photographic skills.

It is our hope that this new guide will inform and satisfy the many 'friends' who visit year by year, by shedding light on one of London's most precious hidden secrets.

James Thomson
31st Master of Charterhouse

ACKNOWLEDGEMENTS

The editor gratefully acknowledges contributions from James Thomson, the Master, Brother Stanley Underhill, and Harriet Richardson of English Heritage, and the photography carried out by Brother Brian Newble and Derek Kendall of English Heritage. Advice was generously given by Dr Claire Gapper on the plaster panel; Carol Galvin on Thomas Sutton's tomb; Dr Michael Kerney on the stained-glass windows in the chapel; and Dr Ian Roy on the militaria on the organ screen.

COPYRIGHT DETAILS OF ILLUSTRATIONS

INTRODUCTION

Sutton's Hospital stands, somewhat discretely, on the north side of Charterhouse Square. This is close to Smithfield and London's busy traffic, yet it is a peaceful spot that has rightly been described as 'a place of leafy seclusion'. But it has not always been so. The square is the site of a Black Death burial ground, created in 1349 as plague swept through London. The gatehouse is that of the Charterhouse, the Carthusian priory, established here in 1371, and on the gate itself was fixed a limb of Prior John Houghton, whose defiance of Henry VIII cost him his life. And the range of buildings visible beyond the gatehouse gives only a hint of what lies within. These buildings are one of the best preserved, yet least known, historic sites in London. The priory was converted in the 1540s into an aristocratic mansion and then, in James I's reign, into an almshouse and school. The almshouse was the largest ever established in England, and the school developed into one of the leading public schools. In 1872 the school was moved to a new site at Godalming, but the almshouse for elderly gentlemen, now designated Sutton's Hospital in Charterhouse, still occupies the buildings, an architectural gem incorporating fabric from the mid-fourteenth century to the turn of the twenty-first century.

HISTORY

THE CARTHUSIAN PRIORY

Bubonic plague appeared in Europe in 1347 and spread rapidly across the continent, reaching England in the summer of 1348 and continuing through the following year. In London the cemeteries were quickly filled and 'very many were compelled to bury their dead in places unseemly and not hallowed or blessed; for some, it was said, cast their corpses into the river'. New burial grounds were needed and Sir Walter de Mauny, one of the king's leading commanders, leased from St Bartholomew's priory a plot of land called Spitalcroft, in West Smithfield, as a graveyard. He built a cemetery chapel on the land.

According to a papal bull of 1351, more than 60,000 victims of the Black Death were buried there, and the foundation charter of the Carthusian priory established on the site twenty years later referred to 50,000 interments. These are improbably high figures, for London's population before the plague struck was no more than 80,000 and probably much lower, and a part of the site was not used for burials.

Quite soon after the epidemic, de Mauny resolved to found a Carthusian priory. But the process was a prolonged and difficult one, especially the acquisition of the title to the site, so that despite the efforts of Michael Northburgh, Bishop of London and another of Edward's councillors, not until 1371 did de Mauny acquire the papal licence needed to establish the priory. By that time he was described as 'much stricken in years' and, although work on the buildings began almost at once, he died before they were completed, in January 1372. He was buried

in the cemetery chapel, which had become the priory church. The anonymous chronicler of the foundation of the priory wrote that Sir Walter was 'an approved man, and in all things laudable, both in matters relating to religion and those of human knowledge'.

De Mauny's funeral was a great occasion, attended by the king and his sons, the senior clergy and members of the nobility. He had already appointed Henry Yevele, the king's mason, as surveyor, to lay out the priory. Yevele set out the great cloister on the north side of the church. Each of the twenty-four monks occupied a cell, actually a two-storey house, built around the great cloister. The prior's cell stood in its south-west corner.

A burst of activity in 1405-6 saw the construction of the little cloister, probably the guest-house on its west side, and the boundary wall and gatehouse adjoining the burial ground. But the altar in the chapter-house was not consecrated until 1414 and the building of the cells continued for a few more years. A piped water supply was laid on in 1431, from which each cell was provided with running water from a conduit house in the centre of the great cloister.

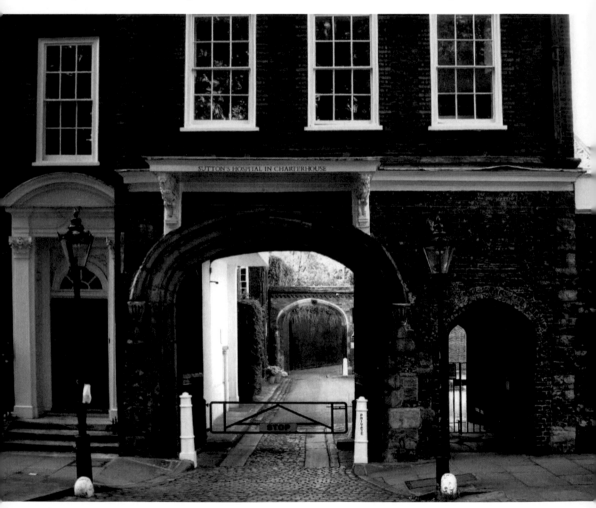

The gateway to the Carthusian priory, early 15th century, with the priory's inner gateway beyond.

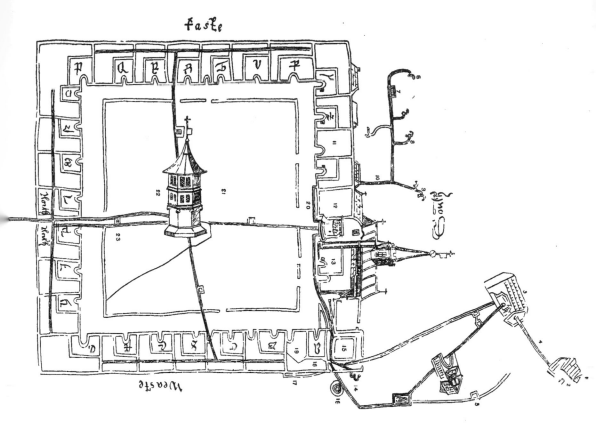

Plan of the Carthusian priory, redrawn from the mid-15th century original.

This was paid for by the London citizen and grocer William Symmes, and Anne Tatersale. Symmes also made donations for maintenance of the water supply and a further sum for paving the great cloister alley. His contributions totalled at least £693 – the equivalent of £7 million today - and his commitment to the priory was such that he joined the brotherhood in 1418.

Further buildings were added in the early sixteenth century. The London Charterhouse was a flourishing community during the early Tudor period, having no problem attracting new monks. The young Thomas More took part in their spiritual exercises between 1499 and 1503. William Roper, his son-in-law, wrote that More was 'religiously lyvinge' in the Charterhouse, while he was studying law. The priory's achievements and reputation at this time owed much to the influence and leadership of William Tynbygh, prior from 1500 until 1529. By the early 1530s it contained the prior, the procurator, twenty-five monks, twenty-one priests, three professed religious (who had taken their vows but were not ordained), and thirteen lay brothers.

This was brought to an abrupt end. Henry VIII's actions in establishing himself as Supreme Governor of the English church met with greater resistance from the Carthusians than from any other monastic order. John Houghton, the prior, and six monks were executed and nine others died in prison. The house was surrendered to the king in June 1537, but the eighteen remaining occupants were allowed to stay until it was suppressed in November 1538.

The buildings remained in the king's hands until 1545 and for a time were used for storing the royal tents and pavilions. In 1545 they were acquired by Sir Edward North (later Lord North), Chancellor of the Court of Augmentations, which disposed of monastic property. He built a mansion there, incorporating some of the priory's buildings, including the gatehouse, but demolishing the church, the great cloister and the little cloister. The chapter-house was adapted as the chapel.

A new courtyard, now Master's Court, was created, with the great hall on its north side. The range on the south side, between Master's Court and Entrance Court, had a long gallery at first-floor level. West of Master's Court a secondary courtyard was formed, Wash-house Court, retaining the monastic ranges on its north and west sides.

North was compromised by the attempts in 1554 to prevent Henry VIII's daughter Mary from acceding to the throne and he briefly lost possession of the house, but subsequently regained it. His plan to sell the property to Thomas Howard, fourth Duke of Norfolk, was completed by his son in 1565, after North's death.

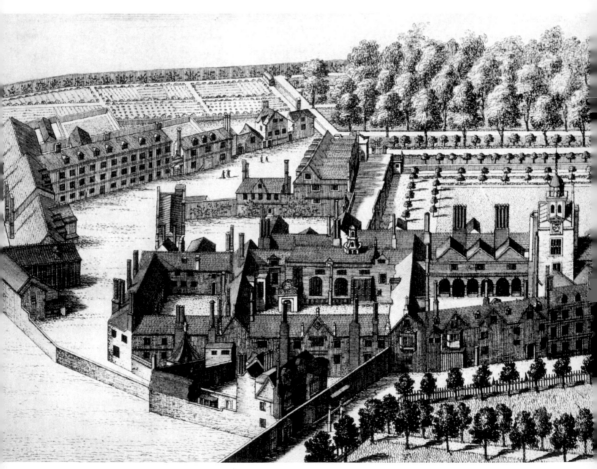

Johannes Kip's perspective view of the Charterhouse, *c.*1688-94.

Now known as Howard House, this was the duke's principal London house and he spent quite lavishly in making changes and additions. His plotting with Mary, Queen of Scots, to depose Elizabeth I and place Mary on the throne, with himself as her consort, were known to the government for a number of years. In 1571 Norfolk was kept under house arrest at Howard House and in 1572 he was executed for his part in the plot centred around the Florentine banker Roberto Ridolfi. A rising in England with foreign support would place Mary on the English throne, and she would also regain her throne in Scotland. Roman Catholicism would be restored.

The building work undertaken during the period of Norfolk's house arrest included the installation of the elaborate screen in the great hall, the remodelling and extending of the great chamber, the rebuilding of the surviving western section of the cloister walk of the great cloister, with a brick vault and a terrace walk above, and the erection of a new tennis court.

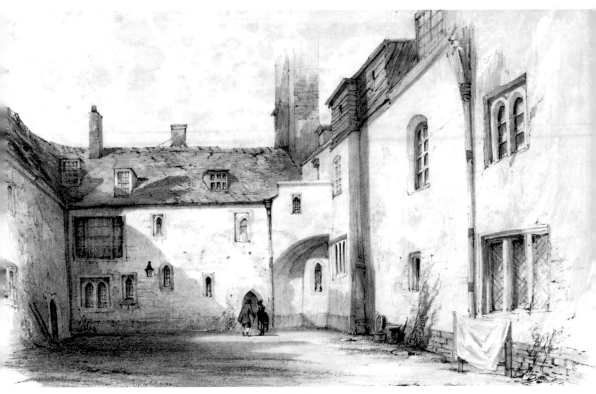

Wash-house Court, by Charles Walter Radclyffe, c.1850.

After Norfolk's death, the Charterhouse passed to his eldest son, Philip Howard, who held the courtesy title of Earl of Surrey and succeeded his grandfather as Earl of Arundel in 1580. He did not occupy the house, which was used as the Portuguese embassy between 1571 and 1577. Thomas Lord Paget, a prominent Roman Catholic, also lived there in the late 1570s; he fled to France in 1583 after being suspected of plotting on behalf of Mary, Queen of Scots. Arundel also corresponded with her and, following his attainder for treason in 1589, was condemned

to death. Although the sentence was not carried out, he remained a prisoner for the rest of his life, and the house passed to the crown. He was canonised in 1970.

George Clifford, Earl of Cumberland, sailor and adventurer, occupied it during the 1590s before Elizabeth I restored it to the Howard family in 1601, when she granted it to Philip's half-brother Lord Thomas Howard. He was created Earl of Suffolk by James I and probably constructed the great staircase and perhaps remodelled the great hall.

But Suffolk's main building activity was the erection of his very large and expensive new mansion at Audley End in Essex. To help finance that prodigious undertaking, in 1611 Suffolk sold the Charterhouse to Thomas Sutton, for £13,000.

THE ALMSHOUSE & SCHOOL

Thomas Sutton was said to be the wealthiest commoner in England. A Lincolnshire man who had been secretary to Ambrose Dudley, Earl of Warwick, he had held the post of Master of the Ordnance in the Northern Parts from 1568 until 1594 and his ownership of coal mines in County Durham, property dealings and money lending had enabled him to amass a considerable fortune. His only child was an illegitimate son, and he decided to establish and endow a charitable foundation at Little Hallingbury, in Essex. These plans were well advanced when he changed his mind and bought the Charterhouse, intending to adapt it as premises for an almshouse and school. He confirmed the legal and financial arrangements, appointed John Hutton as Master and Francis Carter as architect, and began the building work. But he died on 12 December 1611, before much had been done.

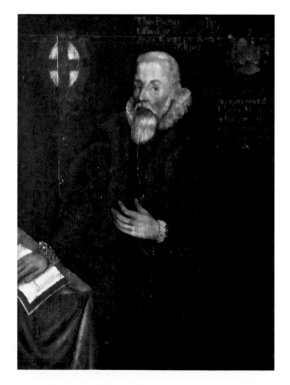

The coat-of-arms assigned to him by the College of Arms was that of the Sutton family of Burton-by-Lincoln. It was adopted as the arms of the foundation, with the greyhound insignia and the motto *Deo Dedi Dante* ('because God has given, I give').

His executors and the governors whom he had appointed fought off a legal challenge to the will by Sutton's nephew and heir-at-law, Simon Baxter, and completed the conversion. In 1614 the almshouse, for eighty elderly men (known as 'Brothers'), and school for forty foundation scholars, or gown-boys, were opened.

Portrait of Thomas Sutton *c.*1590, artist and date unknown.

The foundation was entitled King James's Hospital in Charterhouse. It was greatly admired; Daniel Defoe described it as 'the greatest and noblest gift that ever was given for charity, by any one man, public or private, in this nation'.

The Brothers were to be unmarried men, over fifty years old, who could provide 'good testimonye and Certificat of theire good behaviour and soundnes in religion', those who had been servants to the king 'either decrepit or old Captaynes either at Sea or Land', maimed or disabled soldiers, merchants fallen on hard times, those ruined by shipwreck or other calamity, or held prisoner by the Turks. The scholars were to be more than nine years old, but not over fourteen, and the sons of poor parents. The school also admitted fee-paying boys, both day boys, from its early years, and by the mid-seventeenth century some boarders.

The costume of the early gown-boys.

Under Carter's direction the chapel and tower were enlarged and connected to the main buildings by a new range, a second hall was created on the north side of the great hall, and the tennis court building was enlarged and adapted as a schoolhouse. A new range was built adjoining the west boundary wall, for the Brothers' accommodation, and other parts of the buildings were adapted to provide rooms for them. The Master's Lodge began as three rooms in the east wing of Master's Court, but by the late nineteenth century had expanded to thirty-three rooms within the east wing and much of the south wing, including the long gallery.

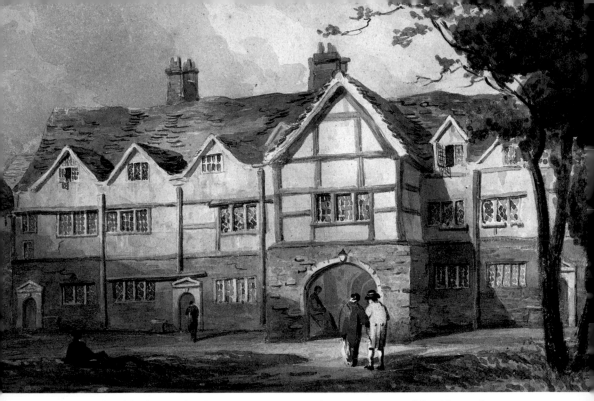

The Brothers' lodgings, built in 1614. By J. P. Neale, 1815, presented by Charterhouse School, 1972.

Following a fire, a range was erected in 1671-2 to Sir Christopher Wren's designs. This in turn was demolished in the 1820s, when new accommodation for the Brothers was erected, creating two new courtyards. These were Pensioners' Court to the north, built in 1828-9 to the designs of the Charterhouse's Surveyor, Redmond Pilkington, and Preacher's Court, begun by Pilkington and completed by Edward Blore in 1839-40. Blore's other work around the site

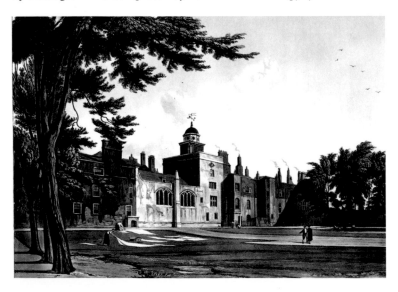

Lower Green and the north side of the chapel, by Rudolph Ackermann, 1816.

Staff and pupils of the school, outside the Norfolk Cloister, by Charles Walter Radclyffe, 1844.

included changes to the chapel, the great hall and the great chamber. His demolition of a part of chapel tower gave it its distinctive asymmetrical appearance.

By the mid-nineteenth century the administration of almshouses generally was coming under critical scrutiny. As the largest almshouse foundation in England, the Charterhouse could not escape hostile attention, and in June 1852 Charles Dickens's *Household Words* carried an article by Henry Morley that was extremely critical of the almshouse and the Brothers' conditions. A refutation by the Master, Archdeacon William Hale, did not quell the controversy that had been sparked by the article and in December 1855 a second one was published in *Household Words*, also unfavourable and extending the criticism to the school. They were potentially damaging, as *Household Words* had a large circulation, but that damage was offset by the publication of William Makepeace Thackeray's novel *The Newcomes* (1853-5). An alumnus of the school, Thackeray presented an affectionate portrayal of the Charterhouse, which he described as the Grey Friars, where Colonel Thomas Newcome was a pupil and later a Brother, and where he died.

Thomas Newcome at the Founder's Day service; a scene from W. M. Thackeray's *The Newcomes*, painted by Daniel Thomas White.

The controversy died away and a report on Charterhouse by a Charity Commission inspector, in 1857, was favourable. It came to be viewed in terms of Thackeray's kindly and mellow perspective, rather than Dickens's harsh judgement. Even so, the popularity of the school had declined and in response to the recommendations of the Clarendon Commission, appointed in 1861 to investigate the condition of nine public schools, and strong pressures within the charity, the school was moved to new buildings at Godalming in 1872. Its part of the site was sold to the Merchant Taylors' school.

Merchant Taylors erected a new assembly hall and class-rooms, demolishing almost a half of the Norfolk Cloister to do so. In 1933 the Merchant Taylors' school was again moved, to Northwood, and St Bartholomew's Hospital purchased the site for its medical college. It is now occupied by Queen Mary, University of London as the Barts and London School of Medicine

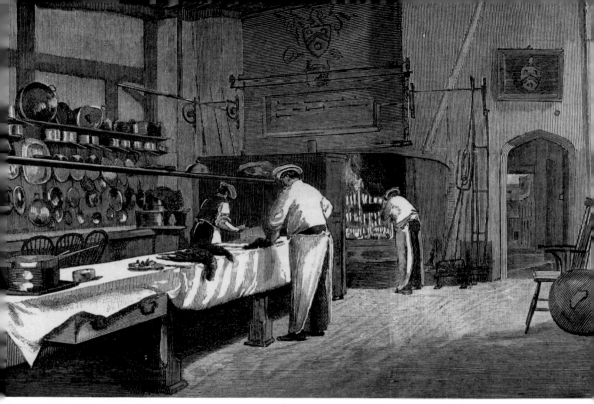

The kitchen, from *The Graphic*, 1885.

and Dentistry, but is owned by an independent charity, the Medical College of St Barts Hospital Medical Trust.

Although Sutton's legacy had provided a considerable endowment, its scale was not proof against economic fluctuations. Because it consisted chiefly of rents from rural manors in southern and eastern England, it was subject to changes in the prices of agricultural produce. The charity's income remained buoyant in the early seventeenth century, but was less so in the late seventeenth and early eighteenth centuries, before rising again to produce a period of prosperity from the late eighteenth century until the sustained fall in agricultural incomes in the last quarter of the nineteenth century. This ushered in a period of relative hardship for the almshouse which lasted until the mid-twentieth century. In 1919 most of the country properties were sold and the sums invested in stocks, and the London estate in Clerkenwell was disposed of during the late twentieth century, leaving little of Sutton's original endowment remaining in the charity's hands. Expenditure had to be pared as income fell. In 1882 the governors decided to reduce the number of Brothers to sixty-eight; by the outbreak of the Second World War only sixty-three were in residence.

The war brought disaster. When it began the decision was taken not to evacuate the Brothers. They were deployed as fire-watchers, successfully so during most of the Blitz in 1940-1. But during the heavy air raid on the night of 10/11 May 1941 a fire bomb that fell on the roof above chapel cloister was not detected in time and started a blaze that spread through the historic core of the buildings. Only the chapel, the north side of Wash-house Court and the western end of the great chamber escaped the fire. The remainder was completely gutted.

Mercifully, there were no casualties and many of the movable objects were saved, including most of the paintings.

The site now had to be evacuated and the Brothers were taken to Godalming, pending rebuilding. The governors appointed as architects John Seely (from 1947 Lord Mottistone) and Paul Paget. They had gone into partnership in 1926 and had remodelled the old chapel at Charterhouse School as a music school, although they were best known for their restoration of the hall at Eltham Palace and the construction of the adjoining house, for Stephen and Virginia Courtauld.

Post-war rebuilding around Master's Court, c.1955.

Shortages of building materials, the licensing system which controlled their allocation, and the charity's financial problems, delayed the beginning of the restoration until 1949. It took nine years to complete. Seely and Paget prepared plans for a new building containing the Brothers' rooms, on the site of Preacher's Court. This would have required the clearance of the nineteenth-century buildings and those in Preacher's Court by Blore were demolished as a first step. But the scheme would have been too expensive; unlike the restoration of the damaged buildings, the costs would not have been payable by the War Damage Commission. The plans for the new building were eventually abandoned.

The number of Brothers that could be maintained by the charity had fallen as a result of the wartime disruption and so fewer rooms were required. These were fitted into the ranges around Wash-house Court and Master's Court. Their accommodation in Pensioners' and Preacher's Courts was no longer needed and was adapted for commercial letting. The medical officer's house at the gate became the Master's Lodge, and he was accommodated in a flat in Preacher's Court.

Seely and Paget's work produced the modern Charterhouse. The pre-war buildings had become shabby and in many ways unsuitable, and the architects took the opportunity not only to restore the buildings but to provide up-to-date accommodation for the Brothers and staff. As the charity's financial position improved in the late twentieth century, it became

possible to maintain more Brothers, and new buildings were erected on the west side of Preacher's Court to accommodate them. The Admiral Ashmore building was designed by Michael Hopkins & Partners and completed in 2000, closing the south-west corner of the court. The range between Preacher's Court and Pensioners' Court was then converted to an infirmary, designated the Queen Elizabeth II Infirmary, opened in February 2004.

The Admiral Ashmore Building, Preacher's Court, completed in 2000.

THE BUILDINGS

GATEHOUSE & MASTER'S LODGE. The Charterhouse is entered through an archway of c.1405. To its right is a length of chequerboard wall of flint and ragstone of the same date. This is the boundary wall insisted upon by the Carthusian Visitors to the English Province, to form a distinct boundary between the priory and the public burial ground. Above the archway is a flat hood, added during the late eighteenth century and supported by brackets in the form of stylised lions. The pedestrian passage to the right of the gate was opened in the 1830s, when the porter's lodge was built. The gateway is flanked by cannon-posts inscribed 'St James Clerkenwell', bought in 1817.

A physician was among the first officers appointed by the governors, who allocated him the house alongside the gateway. This allowed him to receive his own patients without them entering the hospital. The building became so dilapidated that successive physicians complained that it was costing them considerable sums to keep it in repair. The charity therefore agreed to contribute half of the cost of a new house. It was built in 1716 and included two storeys over the gateway. In 1835 the post was re-designated Medical Officer. The house became the Master's Lodge in the mid-1950s.

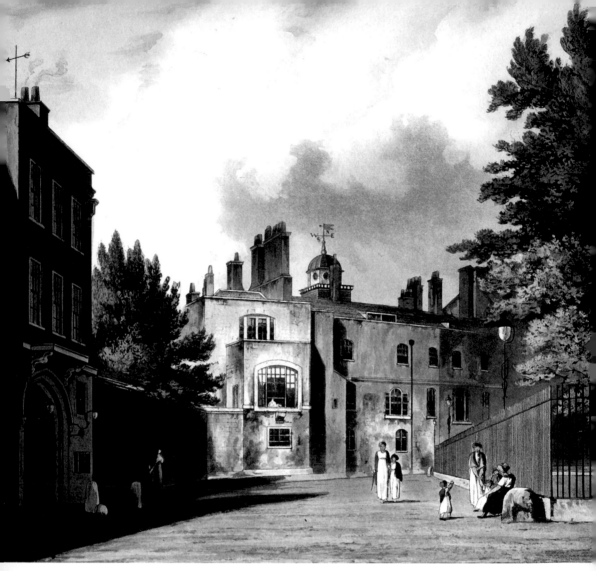

Charterhouse from the Square by Rudolph Ackermann, 1816.

ENTRANCE COURT has the inner gateway of the priory facing the entrance archway. Alongside it is a water conduit house built in 1614. This was incorporated into the Registrar's house, which had its façade where the plain stretch of brick wall now stands. The house was gutted by the fire in May 1941, and the conduit house was revealed, standing almost intact among the ruins. Seely and Paget restored it and gave it its present pyramidal roof, copied from Johannes Kip's view of c.1688-94. The Registrar's house was not rebuilt and a courtyard was created on its site.

The long range facing Entrance Court is the south range of Master's Court, built in 1546 but gutted in 1941. Seely and Paget rebuilt it in the mid-1950s. Nine concrete finials made by Michael Groser stand on the three gables, representing, on the western gable, a greyhound (the insignia of Thomas Sutton), flanked by a gown-boy and a pensioner; on the centre gable, to represent the Salutation, a cross flanked by St Elizabeth and the Virgin Mary; on the east

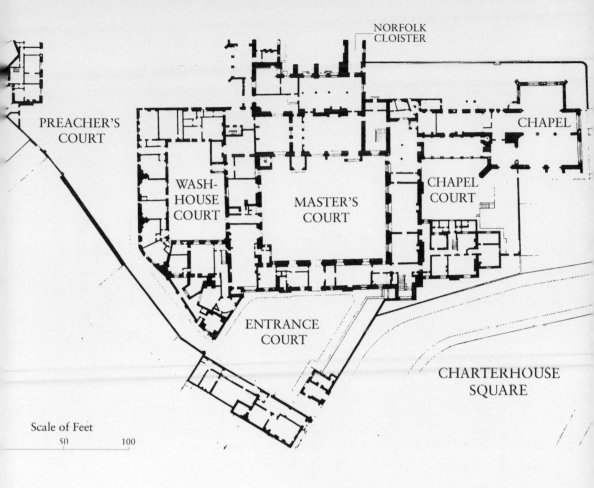

PREACHER'S
COURT

CHAPEL

WASH-
HOUSE
COURT

MASTER'S
COURT

CHAPEL
COURT

ENTRANCE
COURT

CHARTERHOUSE
SQUARE

Scale of Feet
50 100

Plan of the main buildings in 1910.

gable a lion is flanked by Anne of Denmark and James I. The bay of Portland stone looking into
Charterhouse Square was added in 1754.

MASTER'S COURT is reached through an archway from Entrance Court. This was the main
courtyard of North's house, built in 1546, with the great hall on its north side and a long gallery
running the length of the upper floor in the south range. The outline of the monastic little
cloister and the western bay of the priory church are picked out by stone chips set in concrete
strips. Both were demolished to allow the building of this courtyard, and some materials were
incorporated in the new fabric, perhaps including the quatrefoils arranged as a bandcourse
below the windows of the great hall. A statue of St Katherine was recovered from a wall in the
court, which can be dated on stylistic grounds to the late fifteenth or early sixteenth centuries.
The eastern range of the court rests on the foundations of the walls of the church, and the

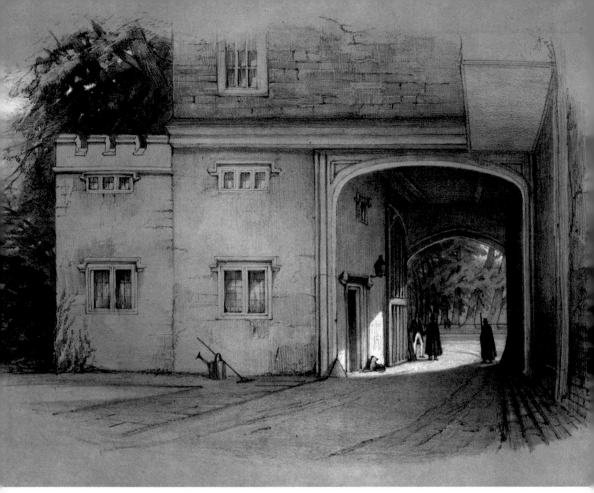

The gateway from Entrance Court, by Charles Walter Radclyffe, 1844.

section of ashlar within the rubble-stone wall of that range is the side wall of the Popham chapel, added to the priory church in 1453.

The courtyard is dominated by the great hall, with its tall windows and projecting bay. A curiosity of the façade is that one of the two large windows rises slightly higher than the other. The front of the hall porch was added in 1628, as was the sundial. The Stuart coat-of-arms dates from the Restoration. The earliest illustrations show the roof surmounted by a turret. This was replaced, almost certainly by Blore, in the early 1840s, with one of a much simpler design.

The walls and windows of the great hall survived the fire in 1941, although the roof was destroyed. When it was replaced, the architects decided not to add a turret or lantern, perhaps to reduce the cost. Their decision has left the roof with a rather bare appearance. The other ranges around the court had to be virtually rebuilt, with new mullioned windows in Clipsham stone, pedimented doorways, figures of hounds as label stops on either side of the arch, and new dormers on the south and east ranges, matching those on the west range. The Master's Lodge and long gallery were replaced by Brothers' rooms. During the restoration, Seely and Paget added a storey to the stair turret in the north-west corner of the court.

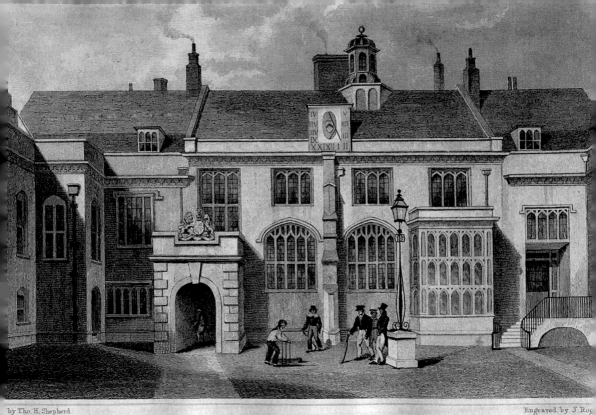

PENSIONER'S HALL, CHARTER HOUSE.

The front of the Great Hall in Master's Court, by Thomas Hosmer Shepherd c.1830.

This had been constructed during the Duke of Norfolk's ownership. The impression created by the restoration is that of a sixteenth-century hall facing a mid-twentieth-century 'Oxbridge' quadrangle.

Master's Court is flanked by Wash-house Court on its west side and Chapel Court on its east side. Both were reached through slypes; that to Wash-house Court remains, but that through the east range was incorporated into the Master's Lodge during the nineteenth century.

The entrance to the great hall, with the Stuart coat of arms.

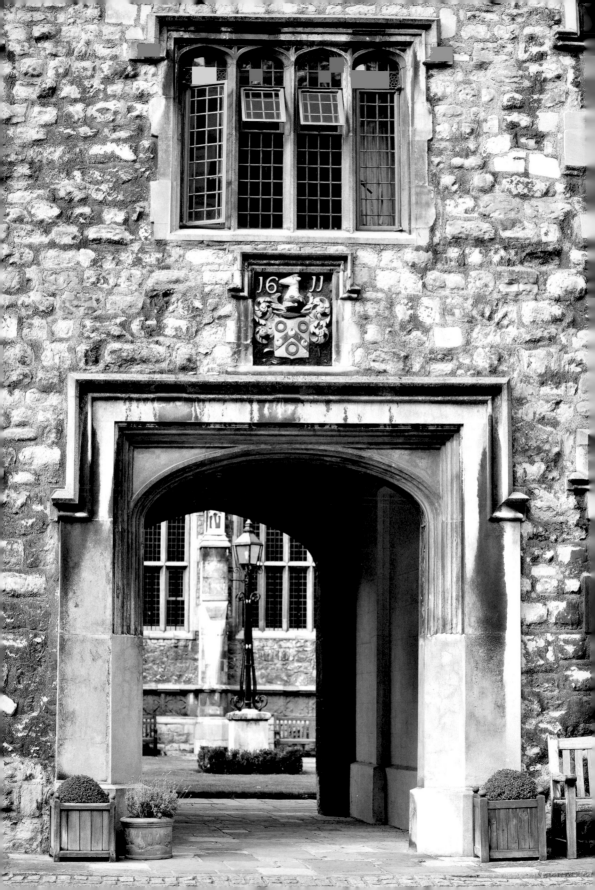

CHAPEL COURT is the site of the priory church, built in 1349 and demolished in 1545. It was a simple rectangular building of five bays, 97 feet by 38 feet. Surviving buttresses incorporated into chapel tower indicate that it was a lofty structure, with walls at least 33 feet high, of a mixture of materials that contained much chalk and Kentish ragstone. The roof was surmounted by a battlemented belfry, topped by a spire. The great bell was dedicated by the Bishop of Lincoln in 1428 and by the Dissolution there was a clock. In 1405 the chapel of St Anne and the Holy Cross was added to the west end of the nave, for the use of the laity. Five more chapels were added later. Those on the south side were dedicated to St John the Evangelist (1437), SS Michael and John the Baptist, containing Sir John Popham's tomb (1453), and SS Jerome and Bernard (1453). The chapels on the north side were dedicated to St Agnes (1475) and St Katherine (1519).

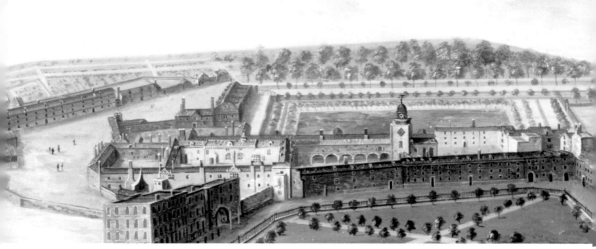

Charterhouse painted in 1756, artist unknown.

The foundations of the church were discovered during excavations undertaken by Seely and Paget in 1947. Its wall lines are marked in the grass. The grave of Sir Walter de Mauny was also uncovered. It contained his coffin, with his skeleton and a lead bulla of Pope Clement VI, assumed to have been attached to an indulgence granted by him to de Mauny in 1351, permitting him to select a confessor for a deathbed absolution. His remains were re-buried and the grave is marked by a slab.

On the east wall of the court is a memorial to the Carthusian martyrs, designed by John Seely. This was erected in 1958 after a long campaign inspired by Fr Geoffrey Curtis, an Old Carthusian who had worked with the Charterhouse Mission in Southwark before joining the Anglican Community of the Resurrection at Mirfield in Yorkshire. The inscription reads: 'Remember before God the monks and lay-brothers of the Carthusian house of the Salutation who worshipped at this altar and for conscience sake endured torment and death 1535-1537'.

◀ View from Entrance Court to Master's Court; the arms are those of Sutton's Hospital.

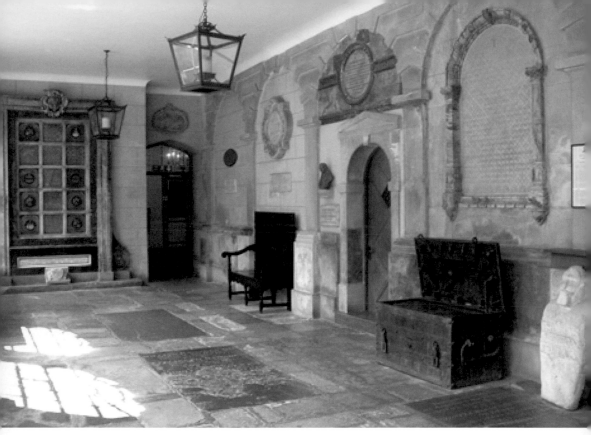

Chapel Cloister: the Havelock Memorial stands against the west wall.

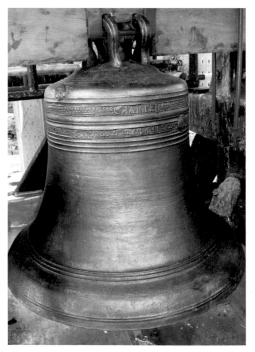

The bell, cast by Thomas Bartlett in 1631.

The names of the martyrs are given and, as Fr Curtis had requested, words from the Benedicite: 'O ye servants of the Lord, bless ye the Lord: O ye spirits and souls of the righteous, bless ye the Lord: O ye holy and humble men of heart bless ye the Lord: Praise him and magnify him for ever.'

On the north side of the court are chapel cloister and chapel tower, with its somewhat over-large Jacobean bell turret. The tower was extended northwards when the chapel was enlarged in 1614, but much of that extension was taken down by Blore, leaving the bell turret, which had been in the centre of the tower, at its northern edge. The bell was cast in 1631 by Thomas Bartlett. It was repaired in 2009.

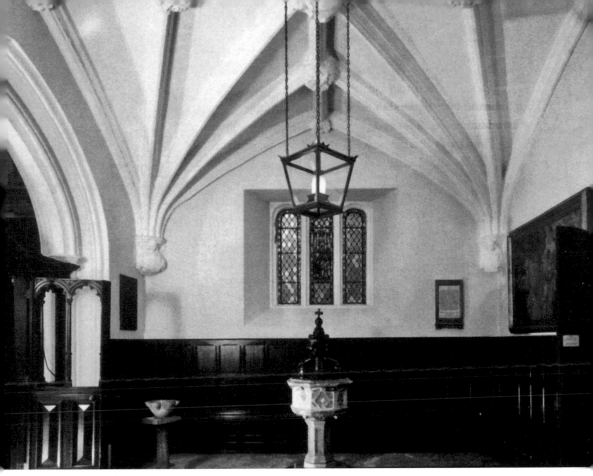

The ante-chapel.

THE CHAPEL is approached through an ante-chapel. This is the lowest stage of chapel tower, originally of two storeys, built in the early fifteenth century, with a third stage added later, perhaps in 1512, the date of the vault. The ground floor served as a vestibule which allowed the monks to pass under cover between the church, cloister walk and chapter-house. Its two altars were dedicated in 1414 to the Holy Trinity and SS Peter and Paul and to SS John the Baptist and Hugh of Lincoln. The upper stage contained the priory's treasury, which has been the charity's muniment room since 1614.

The vault is formed of moulded stone ribs springing from carved angel corbels with blank shields. The carved bosses at the intersections of the ribs carry the instruments of the passion: an angel holding a shield, a spear and hammer on a flower, two scourges on a shield, three nails and two bunches of hyssop. The boss against the centre of the west wall carries the monogram IHS. The south archway was blocked when the priory church was demolished, and that wall has a stained-glass window designed by William Wailes of Newcastle, dated 1853. The font, of Caen stone, is dated 1843.

Beyond the ante-chapel is the south aisle of the chapel, originally the priory's chapter-house. It dates from the early fifteenth century; its altars were dedicated in 1414. It was reconstructed in the early sixteenth century, perhaps in 1512.

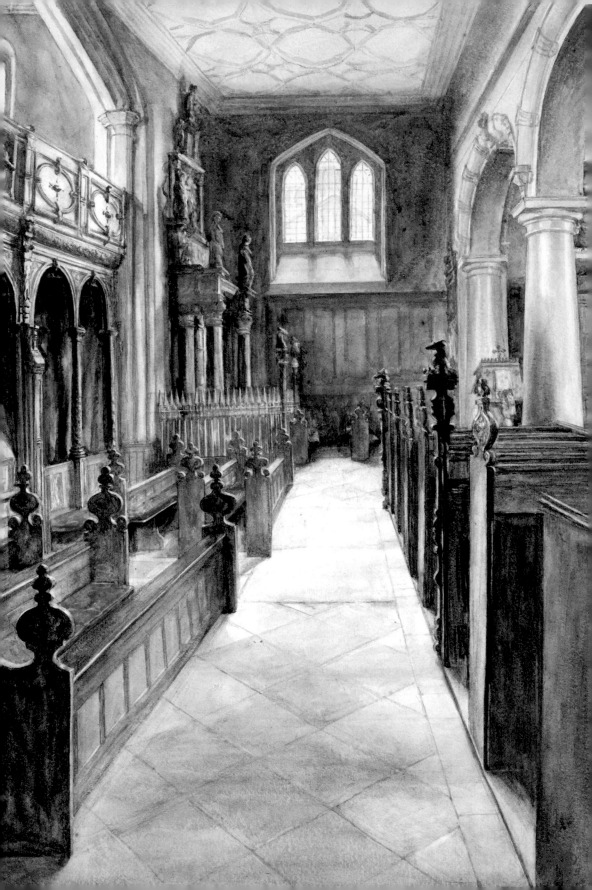

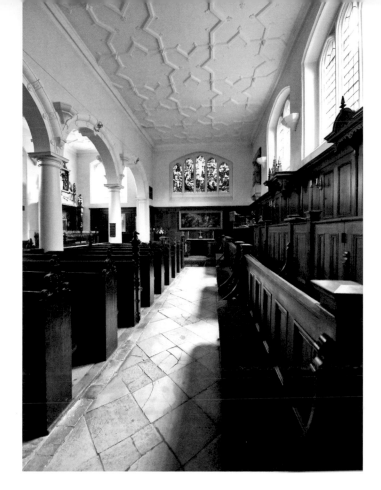

The south aisle of the chapel; the Carthusian priory's chapter-house, early 15th century.

The priory attracted the patronage of Henry VII, as one of eighteen religious houses he selected to perform anniversary services interceding for him and his family. This brought in a small annual fee, and the priory was allocated a bequest of £40 in his will. He died in 1509 and the bequest may have provided funds for the rebuilding.

The rebuilt chapter-house was higher than its predecessor and contained three deep windows on the south side. The easternmost of these has been blocked, and the lower sections of the others were blocked in 1726, when the chapel was renovated by Westby Gill. The east window, too, was inserted at the same time and later shortened. The chapter-house was adapted as the chapel of the courtyard house and subsequently of the charity.

The building was not large enough for the charity's needs and so, as part of his conversion of the buildings in 1613-14, Francis Carter added a second aisle, as long as the existing one and almost as wide. Between them he built a Tuscan colonnade, with three round arches decorated with strapwork and keystones carrying carvings of the Sutton arms. As the numbers of non-foundation pupils increased considerably in the early nineteenth century, more space was needed and Redmond Pilkington designed an addition, erected in 1825 on the north side of Carter's aisle.

◀ The north aisle of the chapel, built in 1614; a watercolour of 1909, artist unknown.

The Jacobean pew-ends have survived in the south aisle and the communion table and pulpit are of the same date. Originally free-standing, the pulpit was truncated and attached to the south wall in the 1850s. Also surviving from the early seventeenth century are the carvings executed by John James for the front of the organ gallery erected at the west end of the south aisle in 1626. Thomas Hamlyn supplied and installed the organ and Benjamin Cosyn was appointed as organist. In 1841 a new organ was acquired from Joseph Walker, which remains in use. Too large for the organ gallery, it was installed in the gallery at the end of the south aisle, which had provided seating for the governors and officers. Blore demolished the gallery in the south aisle, but moved its carved front and reassembled it in the north aisle, with the uprights attached to stained and grained posts. The carvings consist of weapons and the accoutrements of war on two pillars and musical instruments on the other two, emblematic of war and peace. The central cartouche carries the Sutton arms, surmounted by a lion's head; it is enriched with fruit decoration and has side panels carrying cherubs' heads.

Carter did not include a window at the east end of the new north aisle because of the proximity of Rutland House. The aisle's east wall may have been intended as the site of Thomas Sutton's monument, but the governors decided to place it against the north wall. That required omitting one of the three windows intended for that wall, which would have created a façade to match that of the south wall. Sutton was first buried at Christ Church, Newgate Street, and on 12 December 1614 his coffin was transferred to a vault in the Charterhouse chapel.

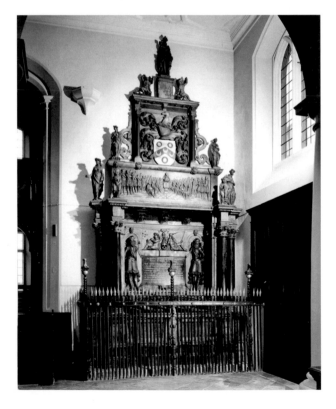

Thomas Sutton's tomb in the north aisle.

The monument above the vault was erected by the partnership of Nicholas Johnson (or Jansen), Edmund Kinsman and Nicholas Stone, who were paid £400. The carving was done by Stone. On the altar-tomb lies the recumbent effigy of Sutton, in a fur-lined cloak. The inscription slab is supported by two captains (men in armour), and above it recline the figures of Vanitas, blowing bubbles, and Time, holding a scythe. The decoration on the piers supporting the canopy includes trophies of war. Above the canopy is a bas-relief panel depicting two groups of figures on either side of a man at a reading desk. This depicts the Brothers in their gowns and other men, presumably the officers, in doublets and hose, hearing a sermon in the chapel. Above the panel are the Sutton arms and a plumed helm surmounted by a greyhound's head. On either side of the tomb stand four slender long-necked female figures, Faith and Hope on the cornice of the canopy, with two putti, and Peace and Plenty flanking the Sutton arms. The positions of the putti and female figures on the cornice were reversed during the restoration work in the 1950s, when the putti were placed at the front. The tomb is surmounted by the figure of Charity with three children, flanked by cherubs blowing trumpets. Sutton's effigy is in limestone, but some of the other carved work is of alabaster, and the columns and inscription slab are of black marble.

The governors were reluctant to permit other monuments to be erected in the chapel, but two more were placed there during the early seventeenth century. That of John Law, one of Sutton's executors, who died in 1614, was included by Johnson, Kinsman and Stone in their contract for Sutton's tomb. Originally on the south wall above the sanctuary, it is now high on the west wall. The painted half-length figure of Law is in an oval recess, flanked by elongated winged female figures which support a deep cornice surmounted by a cupid blowing bubbles sitting astride a skull. In 1624 Francis Beaumont, the Master, died and is commemorated by a monument on the short section of wall opposite Sutton's tomb. He kneels at a prayer desk, flanked by compartments containing books, an hour-glass and skull, and a globe, cube and dividers. On the cornices are figures of an elephant and castle, and a lion.

In the early nineteenth century the governors permitted the erection of two large monuments on the south wall.

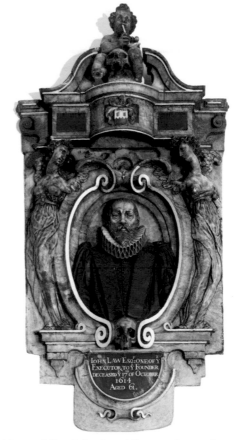

Memorial to John Law, Thomas Sutton's executor, by Nicholas Stone, 1614.

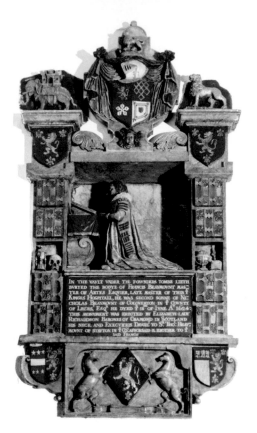

Memorial to Francis Beaumont, Master, d. 1624, maker unknown.

That to Lord Ellenborough is by Sir Francis Chantrey and was executed in 1818. The other commemorates Matthew Raine, Schoolmaster from 1791 until 1811, and his monument, by John Flaxman, was paid for by the scholars. In the mid-1850s a memorial was placed on the wall beneath the gallery, commemorating Oliver Walford (1814-55), Usher at the School from 1838. The delicate medallion portrait is by William Behnes.

Edward Blore made a number of changes in the early 1840s and the ceilings of all three parts of the chapel almost certainly are by him. After removing the organ gallery, he realigned the south aisle so that it is centred on the west arch, rather than on the east window. He then replaced the original pews on the south side with collegiate-style seating, with Jacobean-style canopies over the pews of the principal officers. He also installed a carved wooden screen beneath the west arch of that aisle. The sanctuary was arranged and panelled by him and modified in the 1880s.

In the north aisle, Blore inserted an east window and installed the enriched gallery front and screen of the scholars' extension. The broad shallow arch of that extension shows signs of buckling and indeed Blore demolished part of chapel tower to relieve the weight on the wall to the side of the arch.

In 1844 both of the east windows were fitted with stained-glass by Charles Clutterbuck, depicting the Crucifixion in the south aisle and Christ carrying the cross in the new north one. The latter was removed in 1870, but the Crucifixion remains. The pale figure of Christ has Mary Magdalene at his feet and to one side there is a bearded centurion wearing a yellow tunic and blue leggings leaning on a staff. Despite some wartime damage, this is a fine example of early Victorian stained-glass.

The wall tablets in the scholars' extension commemorate officers of the charity. Those on the stairs to the organ gallery commemorate two distinguished musicians who served as organist. That to the composer John Christopher Pepusch (1667-1752), who arranged the music for John Gay's *The Beggar's Opera*, was installed in 1767 by the Academy of Ancient Music, of which Pepusch had been a founder-member. Beneath it is a later tablet to William Horsley (1774-1858), composer and joint founder of the Philharmonic Society, who is best known for his setting of the hymn *There is a Green Hill Far Away*.

CHAPEL CLOISTER was built in 1614 by Francis Carter to connect the chapel with the Master's Court buildings. Its open arcade consists of six stone arches with architrave, frieze and cornice. It was glazed in 1847.

This was a burial place for officers of the charity; their graves are marked by memorial slabs, and wall monuments commemorate former pupils and others. The small plaster bust of John Wesley, a pupil at Charterhouse, is dated 1770. On the west wall is a monument to Sir Henry Havelock and others who died during the wars in India and the Crimea. It was set up in 1864 and restored in 1960, with slate medallions carrying coats of arms replacing the original enamel ones, which had been lost.

Above the Jacobean doorway at the east end is a memorial tablet to Nicholas Mann, Master 1737-53, who is buried beneath the plain slab in front of the doorway.

PRESENTED BY
OLIVER VAN OSS
FSA
MASTER 1973-1984

Bust of John Wesley, gown-boy, dated 1770.

Brooke Hall, by Frederick Smallfield, 1868.

The room on the north side stands on the site of Brooke Hall, the school's senior common room. It was named after Robert Brooke, Schoolmaster from 1628 until he was displaced by the Parliamentarian authorities in 1644. It was rebuilt after the Second World War as a muniment room.

THE ANTE-ROOM between chapel cloister and the great staircase is a space created by Seely and Paget from the pre-war entrance hall, which was entered by a door from the east wing of Master's Court, which they closed. It contains a plaster overmantel depicting Faith, Hope and Charity, which they moved here from the ruins of Master's Lodge. The modelling of the figures and details suggests the work of a master craftsman, probably executed in the mid-1620s, during Sir Robert Dallington's period as Master. He had been a member of the households of both Prince Henry and Prince Charles. The design is based upon a drawing by Maarten de Vos engraved by Hieronymous Wierix as *Les Vertues Théologales*, following a design by G. de Iode. Faith holds a chalice in her left hand; the sceptre in her right hand was destroyed during the Second World War. Hope holds a crow, the bird associated with her in the Roman era because it calls 'cras, cras' ('tomorrow, tomorrow'). Her robes partly hide the anchor, as is common; the connection is derived from Hebrews, chap.6, v.19: 'Which hope we have as an anchor of the soul.' Charity is suckling an infant, derived from the old image of the *Virgo Lactans*, echoing the Virgin Mary, while the bowl of fruit held up to her by a boy represents earthly charity. The figures are in high relief and are set against a background of a landscape with trees, bushes and flowers. The snail in

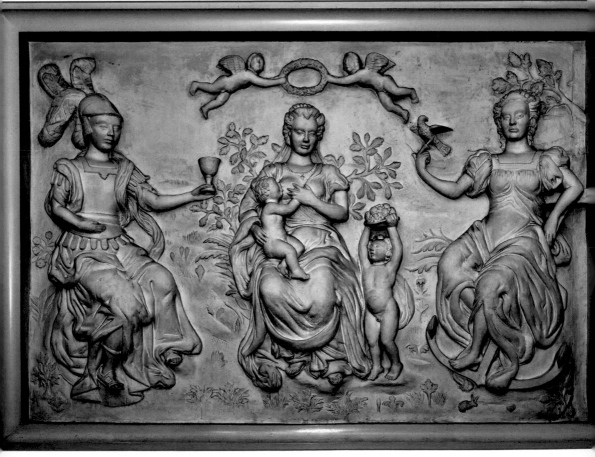

Plaster panel of Faith, Hope and Charity, *c.*1625, maker unknown.

the right foreground seems to have been the plasterer's own humorous invention.

The chest below the panel is German and was made *c.*1600, perhaps in Nuremburg. The decorated plate bears the name of the maker, Jacobus Brebes. How the chest came to the Charterhouse is not known, but its date suggests that it may have been Sutton's.

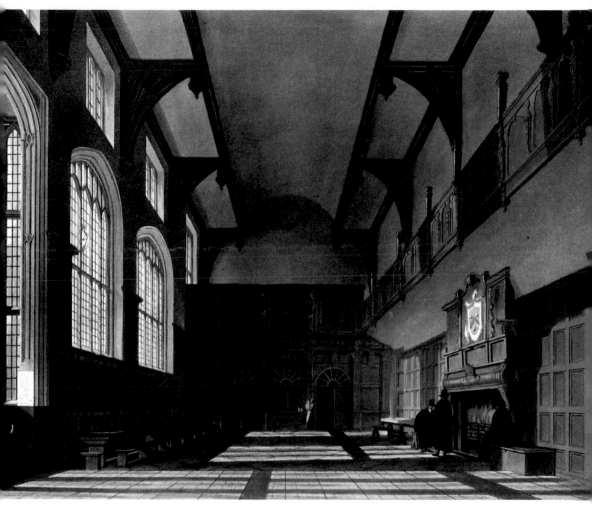

The great hall, by Rudolph Ackermann, 1816.

THE GREAT HALL dates from the building of Sir Edward North's house in the mid-1540s. This magnificent room is now entered at the high end through a doorway with moulded jambs and spandrels decorated with Tudor roses. The dais, lit by the large bay window, has brass strips in its floor marking the line of the wall between the priory's cloister walk and the prior's cell.

In its original form the hall was open to the roof, above the hammerbeams. A ceiling probably was inserted in the early seventeenth century, consisting of a central plaster barrel-vault flanked by flat ceilings. This was destroyed in 1941, although the bases of the hammerbeams survived. The timbers are moulded and the spandrels contain flowing geometric tracery, while the pendants carry carvings of cherub-heads and foliage.

Seely and Paget designed a barrel ceiling of a much wider span and gentler profile than the one which it replaced, with new moulded arched ribs of oak carried on the projecting arms of the hammerbeams and tapering towards the centre. This produced two profiles; that of the plaster, which continues the lines of the hammerbeams, and that of the darkened wood ribs.

The chimneypiece of Caen stone by Edmund Kinsman was installed in 1614. It carries the arms of Thomas Sutton, below which is a cartouche carved with a salamander in flames, emblematic of Constancy. On either side is a group consisting of a cannon, gunpowder keg and a cannon-ball, commemorating Sutton's post as Master of the Ordnance in the Northern Parts.

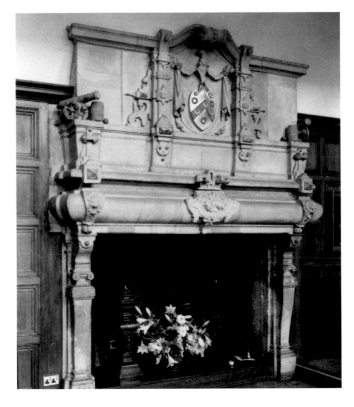

The chimneypiece in the great hall, by Edmund Kinsman, 1614.

Detail of the chimneypiece in the great hall.

Until the post-war-restoration the hall was entered through the porch into the screens passage. The three stone doorways on the west side of the screens passage have moulded jambs and the spandrels of the outer doorways are carved with human figures and foliage, while the centre arch is plain. The richly carved wooden screen was inserted by the fourth Duke of Norfolk and bears his initials with the date, 1571. Its five bays are divided by fluted Corinthian columns on square panelled bases. The front of the minstrels' gallery above is now of four bays, with carved panels separated by pilasters carrying, alternately, male and female figures with bowls of fruit on their heads. The enriched cornice was added by Blore.

The symmetry of the gallery front was spoiled when its northernmost bay was removed for the insertion of the longitudinal gallery, which provides communication at first-floor

level that avoids passing through the great chamber. The gallery probably dates from the first decade of the seventeenth century. Its bays are divided by richly carved pilasters, one of which is partially obscured by Norfolk's screen, and tapering Ionic balusters that rise above the gallery front. Each bay is subdivided by two further pilasters.

THE OLD LIBRARY behind the great hall was created by Carter in 1613-14 within the 1546 building. It was known as the upper hall, as its floor level was slightly higher than that of the great hall. A part of the room was the site of the monks' frater. Both the doorway in the north wall and the chimneypiece were by Edmund Kinsman.

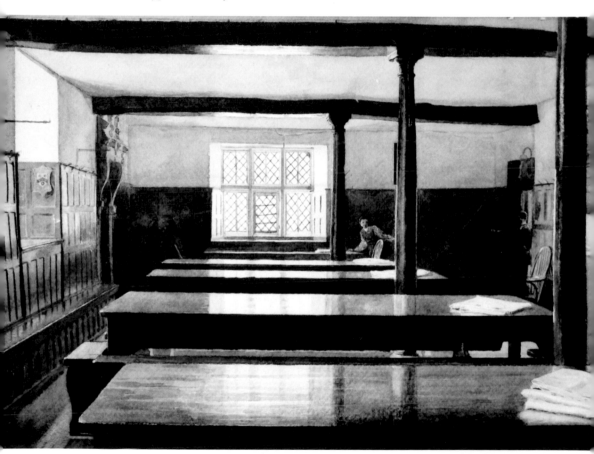

The gown-boys' dining-hall, later the Brothers' library, by Frederick Smallfield, 1868.

Removable wooden panels provide direct access between the two rooms, both of which were used as the Brothers' dining-rooms. When the Master, senior officers and guests ceased to dine with the Brothers and withdrew to Brooke Hall, space was available in the great hall for all of the Brothers, and so from 1846 the upper hall became the gown-boys' dining-hall, approached along the Norfolk Cloister from the school. After the school was moved to Godalming, the room became the Brothers' library. It was wrecked by the fire in 1941.

During the post-war restoration, Seely and Paget lowered the floor to the level of the great hall, while retaining the wooden beams and columns. The columns were inserted in 1750, perhaps replacing earlier posts. To display some monastic tiles in situ, they lowered the floor on the line of the cloister walk still further, with flights of wooden steps between the two levels. The arrangement proved to be hazardous and so that section of floor was raised once more, but leaving the Jacobean doorway to the Norfolk Cloister at the lower level. Seely and Paget also opened the doorway in the east wall, closed since at least 1614, and extended the room at the opposite end beyond the doorway into the screens passage.

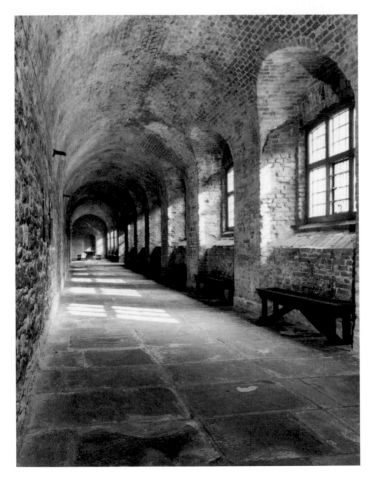

The Norfolk Cloister; the cloister walk of the great cloister, with the brick vault added in 1571.

THE NORFOLK CLOISTER is reached from the old library through Kinsman's doorway, behind which is part of a stair compartment of the 1540s. The rubble-stone west wall of the cloister is that of the monastic cloister, while the brick east wall and vault were built for the Duke of Norfolk in 1571, creating an impressive approach to his tennis court. Decorative outer faces of brick were added on both the west and east sides in 1641. The doorway of Cell B survives almost intact, although restored. This was the first cell to be built, in 1371.

The Norfolk Cloister; the doorway of Cell B, 1371. ▶

To the side of the doorway is a serving hatch (guichet), curved within the thickness of the wall, through which the monk's meals were passed. The hatches of cells C and D also survive on this side of the cloister, that of cell C being wrongly labelled as that of cell D. Wooden doors would have provided coverings for the outer openings of the hatches.

Until 1872 the cloister was the length of the priory cloister walk, almost twice as long as it is now, but in that year the remainder was pulled down by the Merchant Taylors' Company, to make space for its new school hall.

Above the cloister is an open terrace, known as the **QUEEN'S WALK**. It is named for Elizabeth I, who stayed at Charterhouse in November 1558, soon after her accession, in 1561 and again in 1603, shortly before her death. An enclosed gallery stood here on the first two of her visits, but it was demolished when the brick cloister was built. The cloister and terrace provided a choice of walks, for inclement or fine weather. Both overlooked the formal garden on the site of the cloister garth, which was a larger space than the present open ground within the medical college, while the terrace also looked into the privy garden, on its west side. In 2005 a stone designed by Kate Owen was placed in the south-west corner of the medical college's gardens, commemorating the martyrdom of Prior Houghton, the monks and lay brothers.

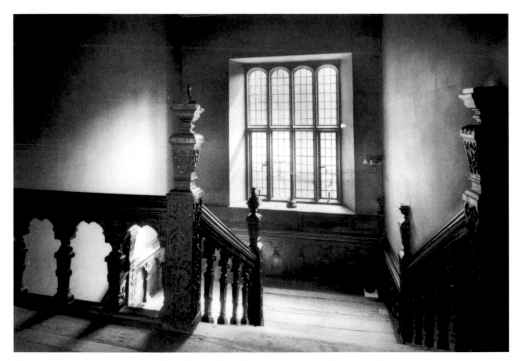

The great staircase, erected in the early 17th century and destroyed in 1941.

THE GREAT STAIRCASE area is entered from Master's Court through a doorway that was inserted in the mid-1950s. The elaborate Jacobean staircase was destroyed in 1941 and replaced by Seely and Paget with a simpler one, echoing its design, but with plain posts and solid panels. Furthermore, its position was changed, as the Jacobean stair had a landing against the south wall. Its destruction allowed the formation of the new doorway.

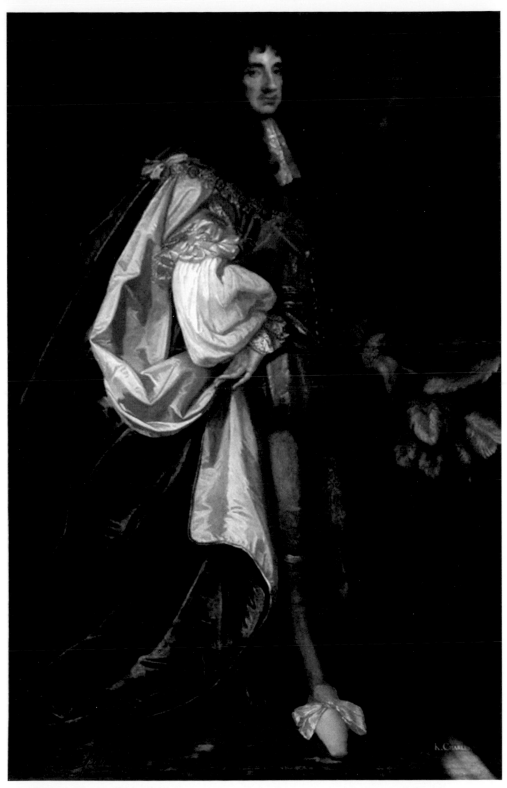

Charles II, after Sir Peter Lely.

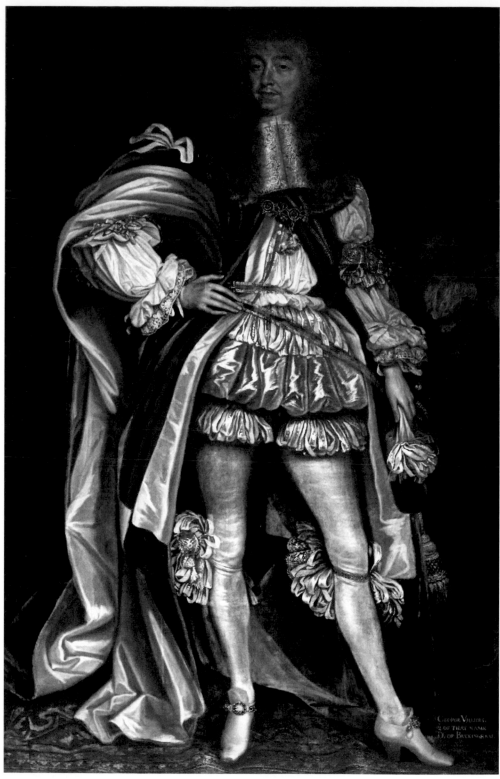

George Villiers, second Duke of Buckingham, after Sir Peter Lely.

THE GREAT CHAMBER is an impressive room, but was given its present dimensions only in the mid-1950s, when Seely and Paget united the original room with the former ante-chamber. Until then the great chamber, formed by North, occupied the western part of this range, and from the late eighteenth century the ante-chamber had housed the Wray Library. This contained the collection donated by the widow of Daniel Wray, a distinguished antiquary who had been a day boy at the school between 1714 and 1718.

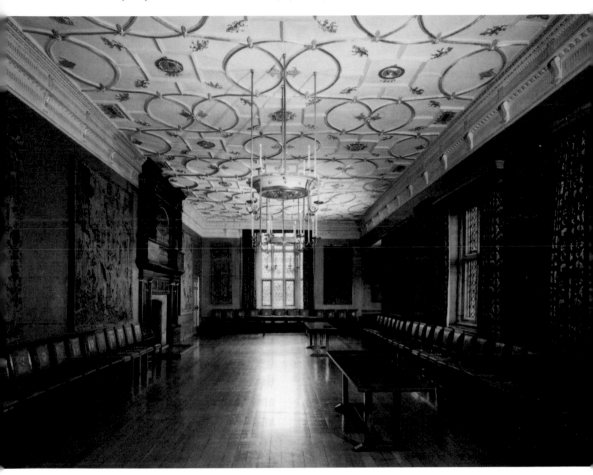

The great chamber, built in 1546 and enlarged *c.*1571 and 1955.

Norfolk enlarged North's original great chamber by adding the bay on the north side. He also installed the fireplace and overmantel. The large overmantel has a plinth supporting two pairs of Ionic columns that are surmounted by an entablature. It is decorated with painted designs and gilding on a gesso base. The columns have representations of the apostles in roundels, the side panels carry figures of peace and plenty, beneath which are the Annunciation and the Last Supper. Both the central panel, with the arms of Charles I, and the panel below it, which carries the shield and initials of Thomas Sutton, were painted in 1626 by Rowland Buckett. Other parts have been repainted and it was extensively damaged in the fire in 1941. It was restored by Robin Ashton, although much of the colour has been irretrievably lost.

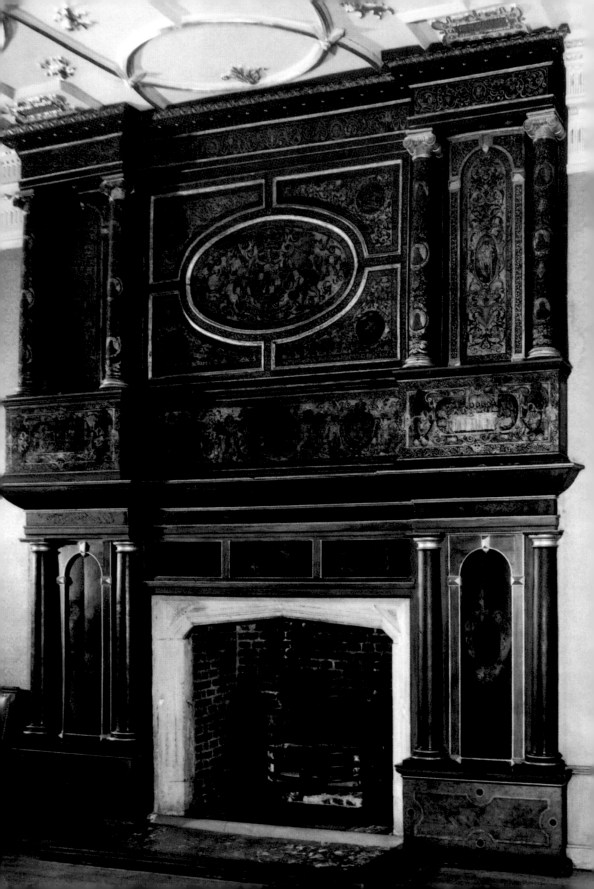

◀ The chimneypiece in the great chamber, *c.*1571, restored 1958 after post-war damage.

Norfolk also installed the decorated plaster ceiling. Only that part within the bay survived the fire in 1941. The remainder is a faithful reproduction by G. Jackson & Sons, incorporating some original elements. The ceiling is divided by moulded gilt ribs and decorated by foliage and rampant lions. The square panels contain the Norfolk arms, the Howard crest and the Fitzalan lion rampant, and the side panels carry the motto *Sola virtus invicta* ('Courage alone is invincible'). Seely and Paget designed the light fittings, which consist of long white electric 'candles' suspended from and standing on a wide circular bowl.

Blore's new buildings erected on the east side of Preacher's Court in 1839-40 blocked the bay window. He therefore opened a large mullioned and transomed window in the west wall, copying the style of the existing lights and evidently re-using some of the panes, for they carry much graffiti with dates earlier than 1840. The bay window was uncovered when the adjoining building was demolished during the post-war restoration. It is also possible that Blore rebuilt the north wall, which had been giving problems since the early seventeenth century.

In 1615 the governors acquired a set of eight Flemish tapestries, which were hung in the 'Great Chambers'. These would have covered virtually all of the available wall space. The tapestries now in the great chamber probably are part of this purchase. The large panels show Solomon and the Queen of Sheba, and an elder sending his son to battle.

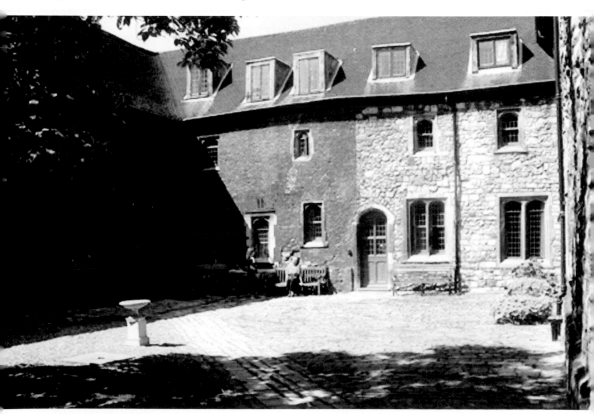

Wash-house Court.

WASH-HOUSE COURT. The other parts of the site can be reached through Wash-house Court, a quiet and appealing corner of the buildings that was the service area of the priory. The stone sections of the north range are the earlier ones, with the brick buildings added in 1531-2. A slype in the north-west corner leads to the outer west face of the court. Diaper work here includes diamond shapes and crosses, some left incomplete. At first-floor level the letters I H are picked out in black bricks. These were the initials of John Houghton, prior from 1531, when the range was erected, until 1535. In the early nineteenth century it was suggested that the letters originally were I H S, and that the S had been removed. The three letters are generally considered to be the first letters of the Latin words *Iesus Hominum Salvator* (Jesus, Saviour of Men). More recently it has been proposed that they are Greek, not Latin, letters. The Greek word for Jesus is ΙΗΣΟΥΣ (iota-eta-sigma-omicron-upsilon-sigma). Sigma may be written as 'Σ', 'S' (the Latin-form) or 'C' (the lunate-form). Thus IHS, or IHC, are the first three letters of 'Jesus'; the two-letter form 'IH' is also recognised. A precedent could have been the notation IHC in the central boss in the treasury, probably installed in 1512.

Between the two large chimney stacks are the vestiges of a shallow archway on the ground floor. That was a doorway for hand-carts, leading into that part of the building used for fuel storage. The building was converted in 1613-14 for Brothers' rooms.

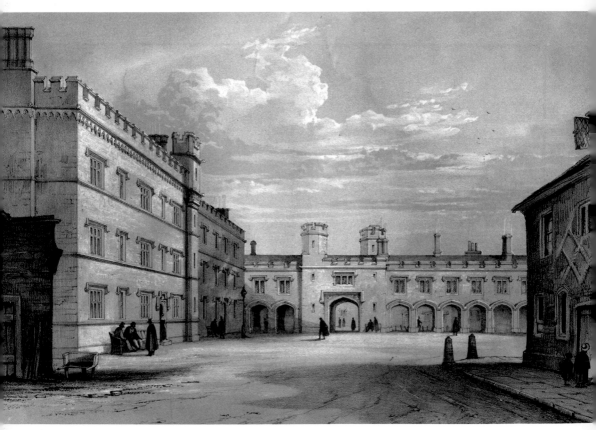

Preacher's Court, by Charles Walter Radclyffe, 1844.

46

PREACHER'S COURT was given its name from the preacher's house in the north-east corner. The north range and adjoining sections on the west and east sides were built in the late 1820s. The Admiral Ashmore Building was completed to the designs of Michael Hopkins & Partners in 2000. It contains the Brothers' library, the core of which consists of 3,000 volumes presented by Brother Peter Day. A library for the Brothers had been formed in 1858 and housed in the former gown-boys' dining-room after 1872, but dispersed after the fire in 1941.

Preacher's Court from the cloisters.

The stone porch on the east side of the court was erected by Seely and Paget in 1950, above it is the Millennium clock. The open cloisters in the north range were blocked during the changes made after the Second World War, but reopened and glazed as part of the conversion of the north range as the Queen Elizabeth II Infirmary, in 2004. The first Brothers' infirmary was created there in 1829.

PENSIONERS' COURT lies to the north. It was the first part of the rebuilding of the 1820s and 1830s to be completed. The Brothers' rooms were arranged on either side of stone staircases. In the mid-1950s the original crenellated parapet was replaced by a pitched roof, giving the court a less collegiate appearance. The buildings are now occupied by private tenants.

The court encloses the area of the original Brothers' burial ground; the later one was set out beyond its north side. Now a garden, it is reached through an archway which has spandrels decorated with *memento mori*. Memorial slabs are mounted on the boundary wall.

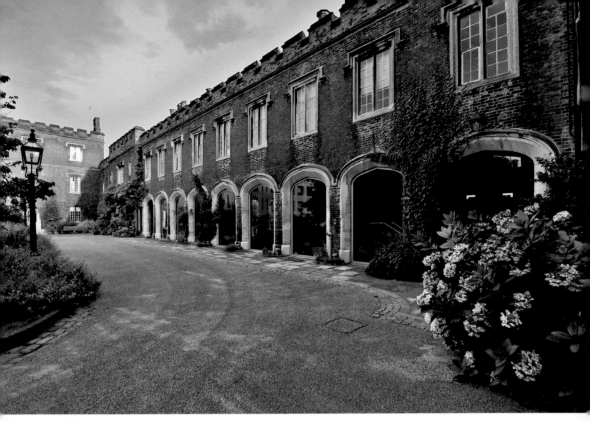

Preacher's Court; the infirmary range.

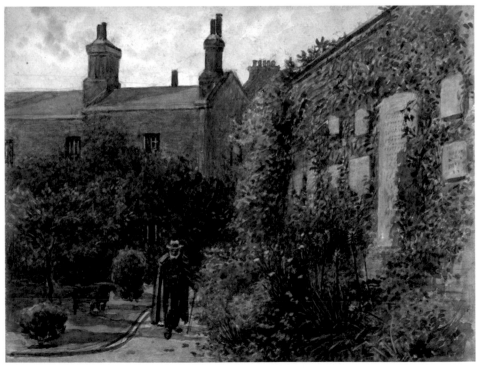

The Master's Garden, formerly the Brothers' burial ground, artist and date unknown.

SOME CARTHUSIANS

THE PRIORY

Little is known of the monks at the Charterhouse, although John Hammersely, who entered in 1393 and remained until his death shortly after 1440, was remembered as 'a man of great simplicity and gentleness'. A generation later John Blacman came from the Carthusian priory at Witham, Somerset. He was a biographer of Henry VI and was appointed warden of King's Hall, Cambridge, before entering the Carthusian order in 1457.

Andrew Boorde also had a distinguished career. He entered the London Charterhouse in 1515, when in his mid-teens, but thirteen years later asked to be released from his vows. He travelled extensively on the continent, studying medicine, and was employed by Thomas Cromwell on a diplomatic mission. Boorde published books on his travels, health and medicine, and on astronomy. He died in 1549.

Among Boorde's contemporaries was John Houghton, who entered c.1515, was sacristan in 1523 and procurator in 1526. He left the London Charterhouse in 1531 to become prior of the Carthusian house at Beauvale, but six months later returned to London to succeed John Batmanson as prior. It fell to Houghton and his monks, a half of whom were under thirty-five years old when he became prior, to face the Henrician changes to the English church. Under Houghton's leadership, many of them felt unable to acknowledge the king as Supreme Governor of the English church, expressed in the Act of Supremacy of 1535. Houghton was the first to be imprisoned and tried. Convicted of treason, he was executed on 4 May 1535, together with the priors of Beauvale and Axholme. He was canonised in 1970.

SUTTON'S FOUNDATION

The list of the first Brothers was headed by Captain George Fenner, a prominent seaman and ship-owner, who had fought in the campaign against the Spanish Armada in 1588. Among the most distinguished Brothers in the early years of the charity was the soldier of fortune, musician and composer Captain Tobias Hume, who entered the house in 1629 and remained until his death in 1645. The book collector John Bagford, who formed the collection of broadsides known as the 'Bagford Ballads', was also a Brother, until his death in 1716, as was Stephen Gray, whose pioneering experiments with electricity led to his election as a Fellow of the Royal Society in 1732. He was assisted by Anna Williams, whose father was a Brother, and she witnessed 'the emission of the electrical spark from a human body'. Anna was a poetess and friend of Samuel Johnson.

Among the distinguished literary figures who were Brothers were Elkanah Settle (1648-1724), who saw himself as a rival of Dryden, but was ridiculed by Alexander Pope, and William Thomas Moncrieff (1794-1857). Moncrieff's greatest success was 'Tom and Jerry, or Life in London', which had a very long run at the Adelphi Theatre and was said to have 'introduced slang into the drawing-room'. John Morton Maddison (1811-91) was a prolific dramatist of the next generation, best remembered for 'Box and Cox', which was set to music by Sir Arthur

Sullivan as 'Cox and Box'. Prominent among the Brothers in the twentieth century were the artists Walter Greaves (1846-1930), who entered in 1922, and Robert Medley (1905-94), who spent the last four years of his life here, and the writer Simon Raven (1927-2001).

The early pupils to achieve prominence included Roger Williams, the founder of Rhode Island, and the poet Richard Lovelace. Thomas Greaves was admitted in 1619 and went to Corpus Christi College, Oxford, in 1627; in 1637 he was appointed Deputy Professor of Arabic in the university. Isaac Barrow, a classical scholar and mathematician, who was at the school in the 1630s, was appointed Master of Trinity College, Cambridge in 1672.

In the late seventeenth century Joseph Addison and Richard Steele were fellow scholars – they later formed a celebrated literary partnership - and in 1714 John Wesley, the founder of Methodism, entered the Charterhouse; he left in 1720 to go to Christ Church, Oxford. Other eighteenth-century pupils included the distinguished lawyers Sir William Blackstone, professor of English law at Oxford University and author of a major history of English law, and Edward Law, first Baron Ellenborough, Lord Chief Justice of England.

Two other prominent Carthusians were Robert Banks Jenkinson, second Earl of Liverpool, who served as Prime Minister from 1812 until 1827, and Charles Manners-Sutton, created Archbishop of Canterbury in 1805. Manners-Sutton is the only Charterhouse pupil who has held the post, although Donald Coggan (Archbishop, 1974-80) was educated at Merchant Taylors' School when it adjoined the Charterhouse.

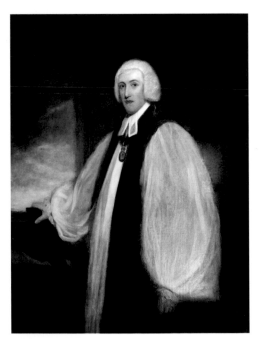

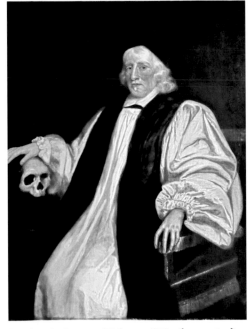

Charles Manners Sutton (1755-1828), Archbishop of Canterbury, pupil, copy by G. R. Ward of an original by Sir Thomas Lawrence.

Benjamin Laney, Bishop of Ely (1591-1675), governor, after Sir Peter Lely.

Francis Turner Palgrave and William Makepeace Thackeray were prominent literary figures of the nineteenth century who attended the school. Palgrave became Professor of Poetry at Oxford and is best known for his two volumes of *The Golden Treasury of Songs and Lyrics*. Thackeray, a pupil from 1822 until 1828, referred to the Charterhouse in his writings, initially as the Slaughterhouse and later as Grey Friars. The artist and illustrator John Leech was a contemporary of Thackeray's, having entered the school at the unusually young age of seven. Sir Henry Havelock pursued a military career, almost all of it spent in India, where he rose to the rank of Major-General, and attracted attention for his campaigns during the Indian Mutiny. Yet he had been known at school as 'Old Phlos' - short for Philosopher - because of his 'general meditative manner' and habit of looking on while others played. The last major figure to be educated at the Charterhouse in Clerkenwell was Robert Baden-Powell, soldier and founder of the Boy Scouts. Indeed, he was one of the scholars who moved to the new buildings at Godalming, where later Carthusians, such as the caricaturist and writer Sir Max Beerbohm and the composer Ralph Vaughan Williams, were educated.

THE ART OF CHARTERHOUSE

According to Augustus W.N. Pugin, that great English architect and designer, 'Art reflected belief'. If this is true, then Charterhouse is packed full of art in the form of memorials adorning the chapel and cloister, and pictures of every medium hanging on the inner walls of Charterhouse, all fitting memorials to Thomas Sutton, the founder of the charity in 1611.

The value of the collection is in its association with Charterhouse and the people whose home it has been since its formation; nevertheless, there are some valuable original oil paintings by Daniel Mytens, Michael Dahl and John Greenhill, and many more after the schools of Sir Peter Lely and Sir Godfrey Kneller. The collection forms a pictorial record of the history of the buildings and people associated with the life of Sutton's Hospital from its establishment as an almshouse and school, with the many changes that have taken place over the past 400 years. It also includes pictures and artefacts which refer to its earlier history as a Carthusian priory and an aristocratic mansion.

The collection consists of almost 400 pictures, including oil paintings, prints, watercolours, photographs, pencil, pen and ink drawings, cartoons and collages, together with nearly 100 picture postcards dating from the end of the nineteenth century onwards.

The oils on canvas include six full-length portraits of governors of Charterhouse during the seventeenth century; it is thought that they were given to the Master of Charterhouse, William Erskine, by Anne Scott, Duchess of Buccleuch, widow of the Duke of Monmouth, a governor. Those of Charles II and George Villiers, second Duke of Buckingham are after Sir Peter Lely, and hang in the entrance hall. Over the gallery in the great hall are portraits of Gilbert Sheldon, Archbishop of Canterbury, James Scott, Duke of Monmouth, and Charles

Talbot, Earl of Shrewsbury, all after Sir Peter Lely, and that of William, Earl of Craven, which is after Gerrit Honthorst. In 1754 the oil paintings were cleaned and repaired and by this time their number had grown to eighteen; again all of them were governors. It can only be assumed that the additional paintings had been donated by anonymous benefactors. In 1762 one of the paintings cleaned was that of Spencer Compton, Earl of Wilmington, which was made into an oval, and that of John Sheffield, Duke of Buckingham was also described as an oval. Today they hang side by side in the Governors' Room.

In February 1845 George Harlow White gave Charterhouse two three-quarter length portraits in oils, one was of Charles Manners-Sutton, restored in 2008, which is a copy by G. R. Ward of the portrait by Sir Thomas Lawrence hanging in Lambeth Palace. The other was of Arthur Wellesley, Duke of Wellington, an original by Henry Perronet Briggs. Both now hang in the old library.

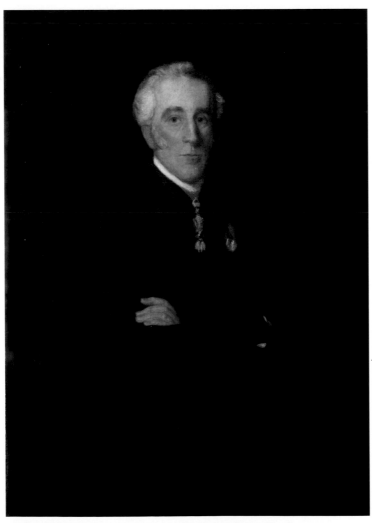

Arthur Wellesley, 1st Duke of Wellington (1769-1852), governor, by Henry Perronet Briggs.

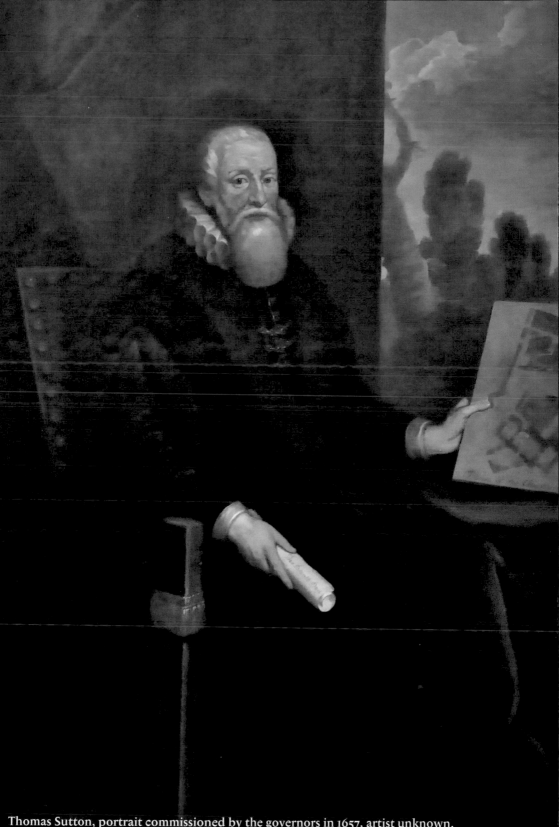

Thomas Sutton, portrait commissioned by the governors in 1657, artist unknown.

The eighteenth and nineteenth centuries saw a great influx of prints, first from the process of engraving and later from lithographs, from artists like William Henry Toms, Robert Havell, Charles Walter Radclyffe and William Westall. These show the interiors of the great rooms of the house, such as the great hall, the great chamber and the chapel. There are also prints of the exterior and interior views of the school buildings and that part of the Norfolk Cloister which was demolished to make way for the Merchant Taylors' School in 1872, and the old Master's Lodge, gutted by the fire in 1941. The Green, formerly the Carthusian's cloister garth, Master's Court, Wash-house Court, Preacher's Court, Pensioners' Court and Charterhouse Square are also amply illustrated in prints from engravings and lithographs.

Martin Benson (1689-1752), Bishop of Gloucester, gown-boy, after Jonathan Richardson.

During the nineteenth century, engravings gave way to watercolours which introduced the artists' particular perspectives of the interiors and exteriors of the buildings and of the school at Godalming. Artists represented in the collection include Frederick Smallfield, William Alister Macdonald and William Wiehe Collins.

Towards the end of the nineteenth century an increasing number of photographs were added to the collection which recorded locations, people and events in a new way thanks to the precision of the camera lens. A recent addition is six original sepia photographs of Charterhouse by Henry Dixon dating c.1880, a gift from Christopher Howse. These now hang in the Wesley Room.

The oldest picture in the collection is a portrait of Thomas Sutton presented to the Corporation of Lincoln by the city's mayor, Edward Blawe, in 1622; it bears the Lincoln city arms. It has been dated c.1590 and is one of two thought to have been painted during Sutton's life. This is on wood and hangs on the great staircase. In 1657 the governors ordered that a portrait of Thomas Sutton should be drawn; this hangs in the great hall. The artist engaged would not have seen Sutton and so would have had to rely upon the effigy on his tomb for his likeness.

The collection was thought to have a painting of the first Brother, Captain George Fenner, admitted to Charterhouse in 1614, but when it was removed for cleaning and restoration in

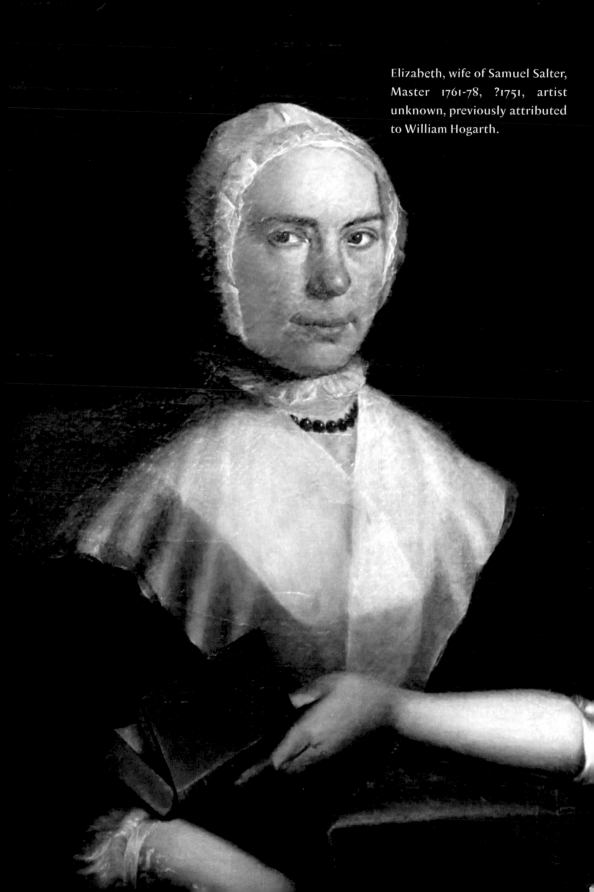

Elizabeth, wife of Samuel Salter, Master 1761-78, ?1751, artist unknown, previously attributed to William Hogarth.

The Schoolroom, by Rudolph Ackermann, 1816.

2005 it was discovered that the painting was in fact of his cousin Admiral Thomas Fenner. Both had distinguished careers at sea, including the defeat of the Spanish Armada in 1588, during the reign of Elizabeth I. Another first in the art collection is a head-and-shoulder portrait in oils on canvas of Elizabeth Salter, wife of the Rev. Samuel Salter, Master of Charterhouse (1761-1778) and described as the first lady of Charterhouse.

The collection of prints, watercolours, photographs and picture postcards has been largely built up over the years by gifts from Old Carthusians or their families, former Masters of Charterhouse, Brothers who have died and those who currently live at Charterhouse. Friends and well-wishers have also donated items, and a few works have been purchased when the opportunity has presented itself. The collection has also been enhanced by gifts of works of art from former Brothers, including Walter Greaves (pupil of James McNeil Whistler), Robert Medley and Adrian Daintree.

The collection also has some interesting artefacts relating to former scholars. These include a bust of John Wesley and a Louis Gluck Rosenthal print dated 1843 showing words taken from the story of Wesley's life, which form the lines of a head-and-shoulder portrait of him preaching from an open Bible. William Makepeace Thackeray has a significant place in the collection with a photograph of him in a frame including a photograph of Captain Thomas Light, a Brother who was admitted to Charterhouse in 1848 at the request of Queen

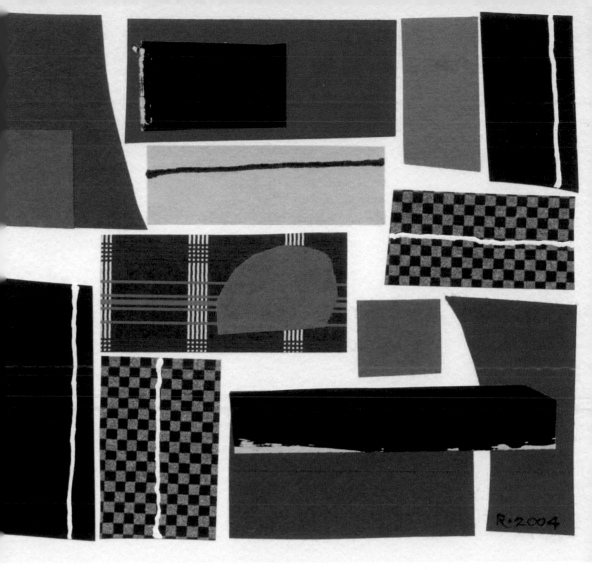

Collage by Brother Patrick Rowe, 2004.

Victoria and whom Thackeray visited whilst writing *The Newcomes*. The photographs are in the Thackeray Room, which also houses a large collection of his works given to Charterhouse by J.A. Whaley Cohen in the late 1950s.

The collection has been recently enriched with works by resident Brothers: Patrick Rowe has given a collection of colourful collages; Jack Bowles seven superb head-and-shoulder sketches using conté crayons on cartridge paper of four Brothers and three members of the staff; and Syd Cain a substantial collection of humorous cartoons drawn from contemporary life at Charterhouse. All these works line the corridors of the Queen Elizabeth II Infirmary.

Illuminated Addresses are added to the collection on the important occasions in the life of Charterhouse, such as the visit of Her Majesty Queen Elizabeth II and His Royal Highness The Prince Philip, Duke of Edinburgh on 11 June 2008, to mark the fiftieth anniversary of the reopening of Charterhouse after World War II. The calligraphy and the coats-of-arms are the

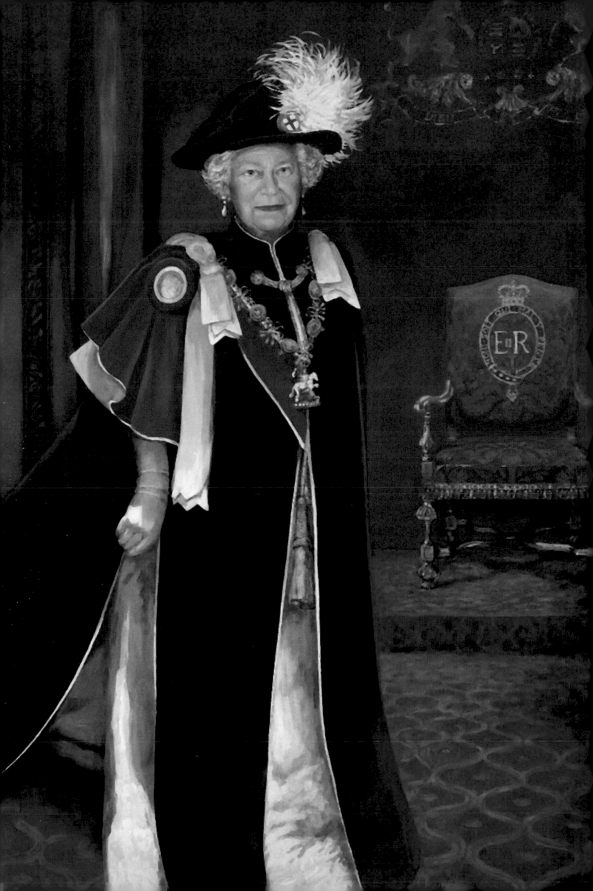

work of the Rev. Eric Griffiths, a Brother. A significant gift in 2006 was a full-length painting of Her Majesty, in the robes of the Most Noble Order of the Garter, by Roger Rimington, which hangs in the Governors' Room.

The most recent gift by Andrew Murdoch, an old Carthusian, is a set of six copies of watercolours, consisting of four pictures of the London Charterhouse and two of Charterhouse, Godalming; these hang in the Infirmary's sitting-room.

The art collection includes examples of every medium used during the last 400 years in reproducing images, including oils and acrylic on canvas and wood, prints from engravings and lithography, etchings, aquatints, watercolours and prints of watercolours, pencil, pen-and-ink drawings on paper, cross hatching, cartoons, print and photographic montages, collages and photography. It has been arranged in groups or by themes, together with suitable captions on the walls of the public rooms and corridors of the Charterhouse buildings in a way that they can be readily appreciated by the serious or casual viewer.

A comprehensive catalogue of the art of Charterhouse is available. The collection of picture postcards has also been catalogued and displayed in a special album. A record of all the memorials and monuments in the chapel and chapel cloister are contained in a survey prepared by the National Association of Decorative and Fine Art Societies in 1990-1.

Thomas Sutton and his munificent charitable gift of Sutton's Hospital in Charterhouse and the Charterhouse School have inspired countless artists over the years to draw, paint and photograph this place and its people. Now that their art work has been collated and displayed you are warmly invited to view this fascinating collection when visiting Charterhouse.

THE COMMUNITY

GOVERNORS & MANAGEMENT

The responsibility of the charity is primarily the care of the community of single elderly men (Brothers of Charterhouse) who live in the buildings of Sutton's Hospital. The sovereign, the consort and the heir are the three Royal Governors and the Archbishop of Canterbury is the Archiepiscopal Governor. The Assembly of Governors consists of the sixteen charity trustees, a body first formulated by Thomas Sutton on 22 June 1611 (Foundation Day). It meets three times a year and is assisted by a number of committees. The governors are responsible for administering some of the funds of the school and are also patrons of ten Church of England livings: two are in the Diocese of Lincoln, one in Norwich, three in Ely and four in Chelmsford (including Little Hallingbury, the site of the Brothers' burial ground). They are mostly places where Thomas Sutton owned property. The staff of the hospital includes the Master, Preacher and Deputy Master, Bursar, Matron, Clerk to the Brothers and Manciple, who constitute the management team.

There is accommodation for forty Brothers in the main buildings and the Admiral Ashmore Building. Here the Brothers have a pair of rooms, bedroom and sitting room with en-suite facilities with a shower and a small kitchen-area. In addition there are ten rooms in the Queen Elizabeth II Infirmary, which has three-star status as a registered care home providing nursing with the Care Quality Commission, where Brothers are accommodated when they require personal care. Once he has entered, a Brother will be looked after for the remainder of his life.

The Brothers, who are in need of financial and social support, are selected from a wide variety of backgrounds, which includes teachers, clergymen, writers and editors, musicians and artists, and many have served in the armed forces.

Thomas Burnet (c.1635-1715), Master, 1685, attributed to Benjamin Wilson.

Brother Philip Lewtas (2000), drawn by Brother Jack Bowles.

John Portman, the porter (1999), drawn by Brother Jack Bowles.

At entry they have to be between sixty and eighty years old and in good health. They must also have a desire to live together in the community following a very simple set of rules. All meals are taken together in the splendid setting of the great hall, but their accommodation is entirely private. A programme of lectures, musical events and outside visits is arranged by the Brothers' Social Committee and Music Group, and there is an active Brothers' reading group. Other roles undertaken by the Brothers include those of organist, pianist, clerk of the chapel, photographer, tour guides, editor of the Charterhouse Magazine (a twice yearly publication), cataloguer of the extensive artwork, collage artist and cartoonist. The Brothers meet with the Master and Bursar as a group at least four times a year to discuss current topics.

A Brother, unknown, *c.*1920 wearing the traditional gown and holding a top hat.

Charterhouse is a Church of England foundation and the chapel functions on a daily basis, although attendance is not a requirement for the Brothers. The services are ordered according to the Book of Common Prayer and each week-day Morning Prayer is at 0800 and Evening Prayer at 1730. Holy Communion is celebrated at 0945 on Sundays and on most Holy Days and Saints Days. There is a small chapel in the Queen Elizabeth II Infirmary, dedicated to St Bruno, the founder of the Carthusian Order (1084). The first Brothers' burial ground was in the area now enclosed by Pensioners' Court; the Master's Garden adjoining Clerkenwell Road was then used from the 1820s until 1854, when a plot was acquired in Tower Hamlets Cemetery. In 1929 part of the churchyard of St Mary the Virgin, Little Hallingbury in Essex became the Brothers' burial ground, where a memorial service takes place each July.

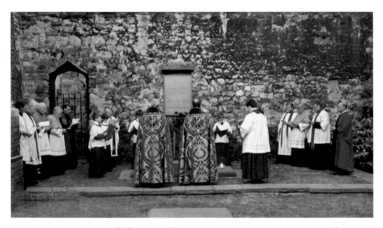

Commemoration of the Carthusian Martyrs, 4 May 2007; the first public Roman Catholic service at Charterhouse since the Reformation.

CALENDAR

Each year there are a number of special days. These include the summer garden party to which the Brothers invite members of their family and friends; the anniversary of the founder's death (12 December 1611) is marked by a luncheon for the whole community; and Founder's Day, when representatives of Charterhouse School and Old Carthusians attend.

The following days are also observed:

15 January: the anniversary of the burial of Sir Walter de Mauny in 1372.

25 March: the Annunciation, which was the dedication of the Carthusian Priory, founded in 1371.

4 May: the anniversary of the martyrdom of St John Houghton, the last Prior, and his companions in 1535.

24 May: celebrating the life of John Wesley, who was a scholar from 1714 until 1720.

22 June: Foundation Day, when the Assembly of Governors was constituted in 1611.

6 October: commemorating the death in 1101 of St Bruno, the Founder of the Carthusian Order.

12 December: the death in 1611 of Thomas Sutton, founder of the charity, and the translation of his remains in 1614.

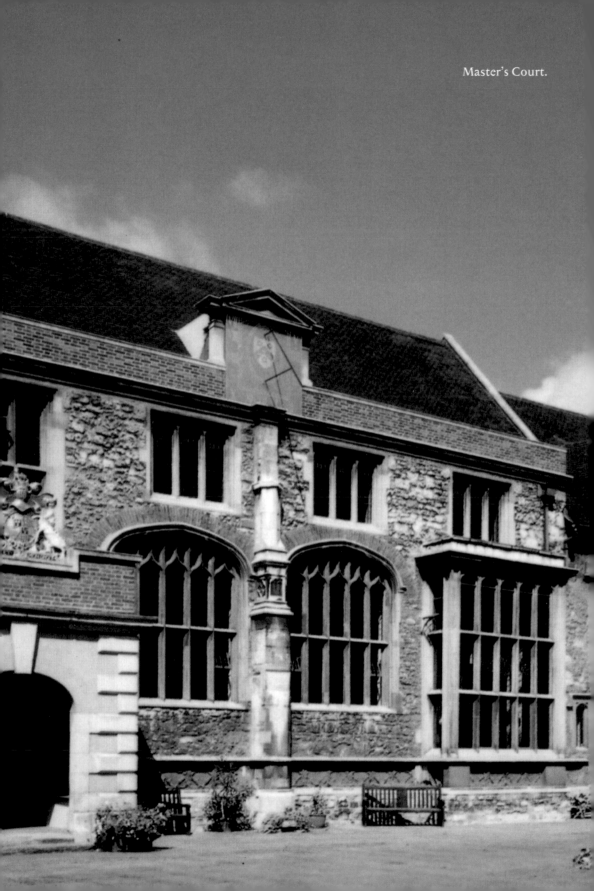